Simon's disguise

Gilles Tibo

Translated by Sheila Fischman

Tundra Books

My name is Simon
and I love disguises.
Today I'm king of the hill!

Unfortunately,
I can't play very long.
A donkey has stomped on my cape!

HEE HAW... HEE HAW!
I lose my balance
and fall in the hay!

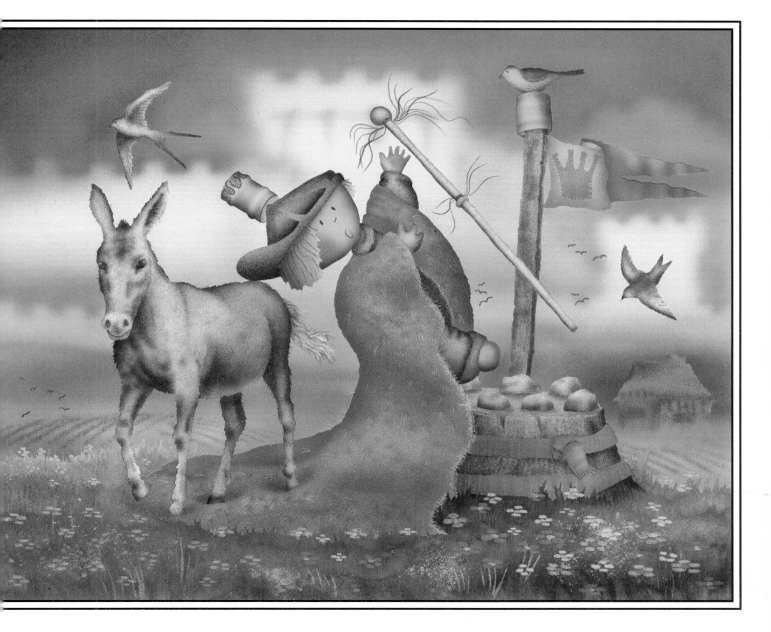

I disguise myself as a magician.

ABRACADABRA!
The sheep and the hens and the pigs
all turn into rabbits.

They jump everywhere!
BA-BOOM! BA-BOOM! BA-BOOM!
I tumble down backwards
and roll in the grass.

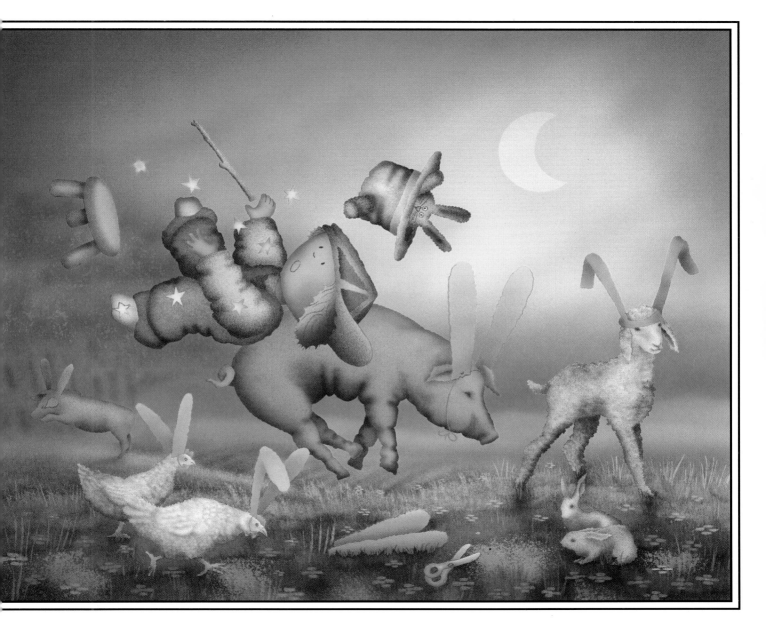

I pick up my lance and my armor
and turn myself into a knight.
I shout:
"CHARGE! CHARGE!"

But I don't go very far.
I move at the speed of a turtle...

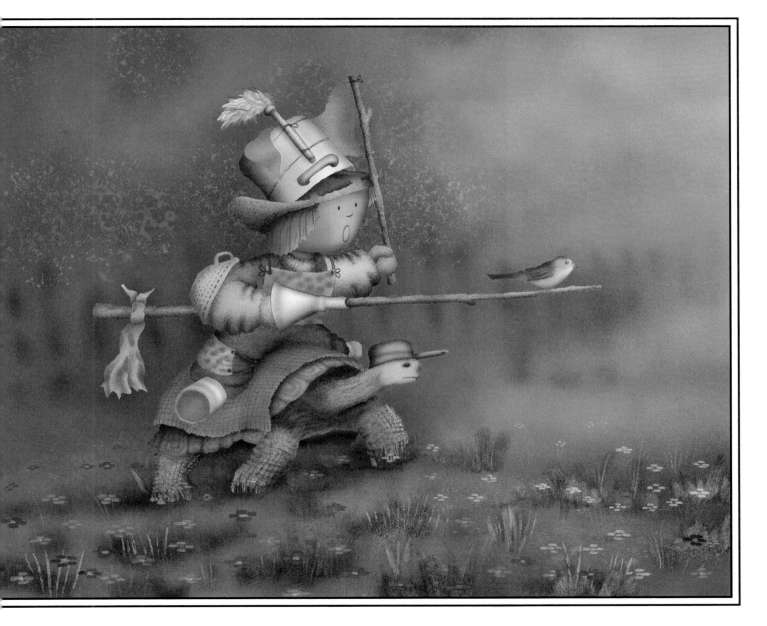

I disguise all the animals as clowns.
FLIP... FLAP... FLOP...
I make dangerous leaps.

Nobody laughs.
Nobody applauds.

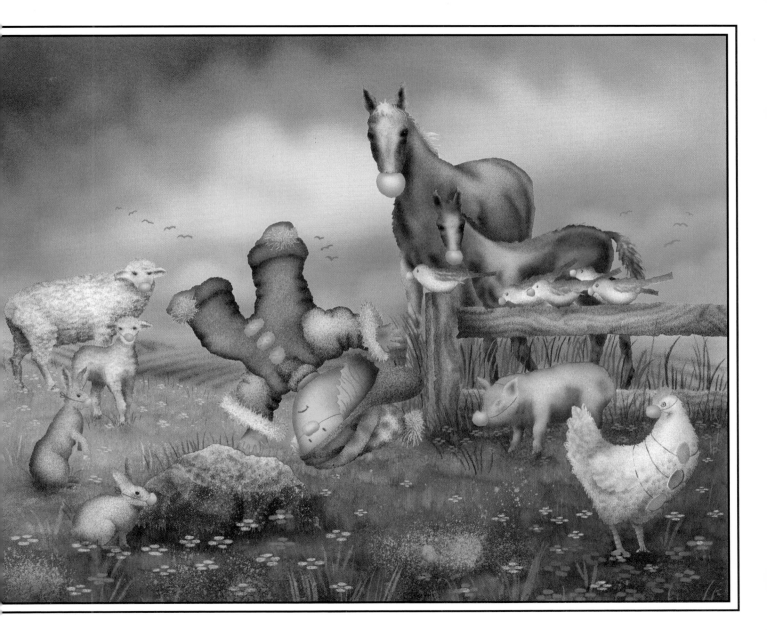

I go to see my friend the clown.
He tells me:
"Leave the animals in peace, Simon!
Since you like disguises,
I'll show you the secrets of make-up...
Nobody will know who you are."

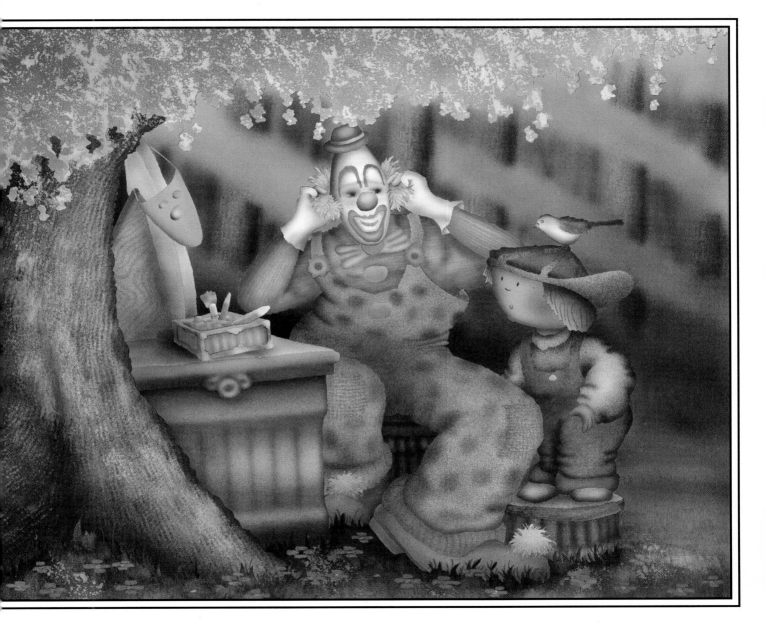

I disguise myself as a bear.

The bees don't recognize me.
They think I'm the bear
who stole their honey!

BZZ! BZZ! BZZ!
I race away and dive into the pond.

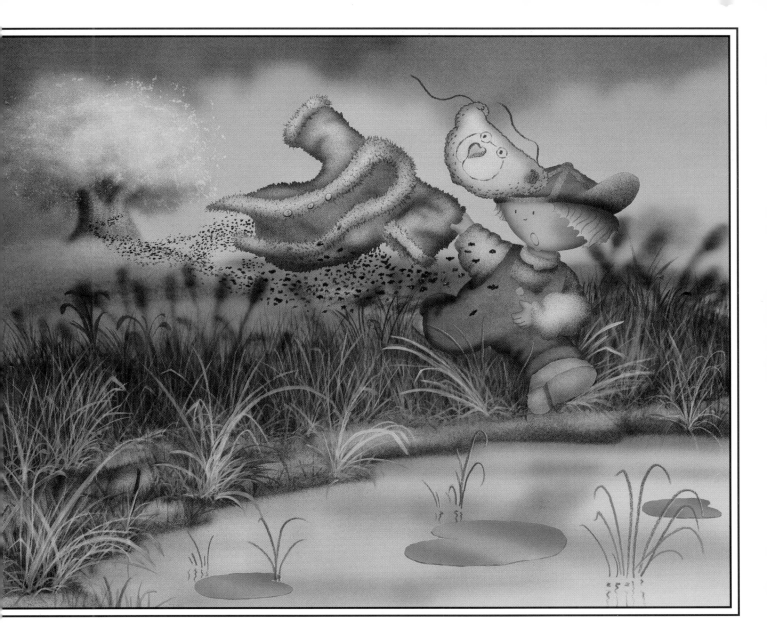

I disguise myself as a tree trunk.
Nobody recognizes me.

Suddenly a big woodpecker
lands on my head!
RAT-A-TAT-TAT! RAT-A-TAT-TAT!

As I fly away,
I frighten all the birds.

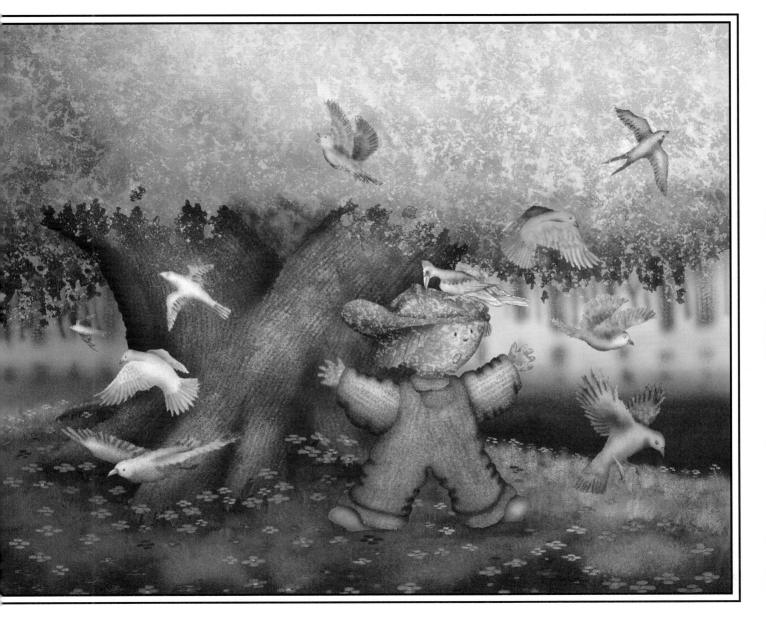

I disguise myself as a rock.
Marlene looks for me everywhere!

To surprise her, I move just a little.
Startled, she cries:
"AAAAAAAAAHHHH!"

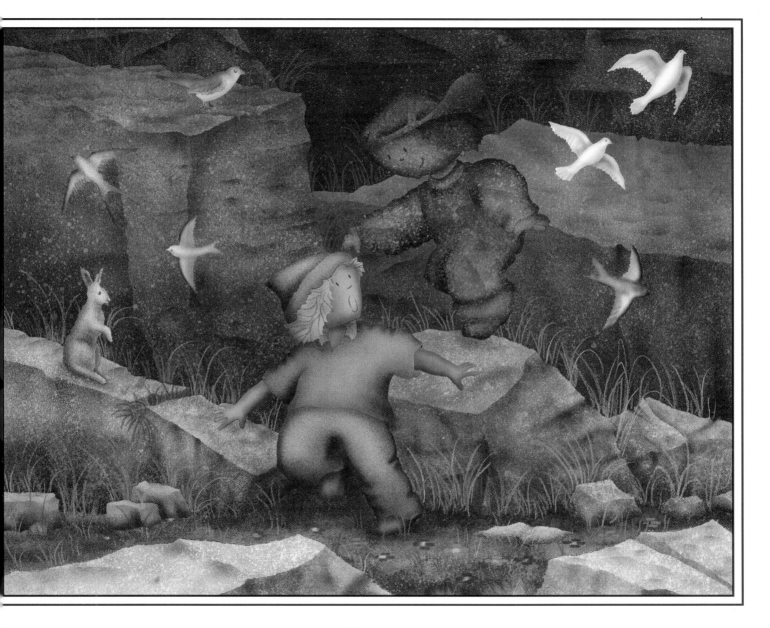

Disguised as red flowers,
Marlene and I
play in the field.

All at once,
RRRAAAH! RRRAAAH!
The bull gallops up to us!
We race away as fast as our feet can run.

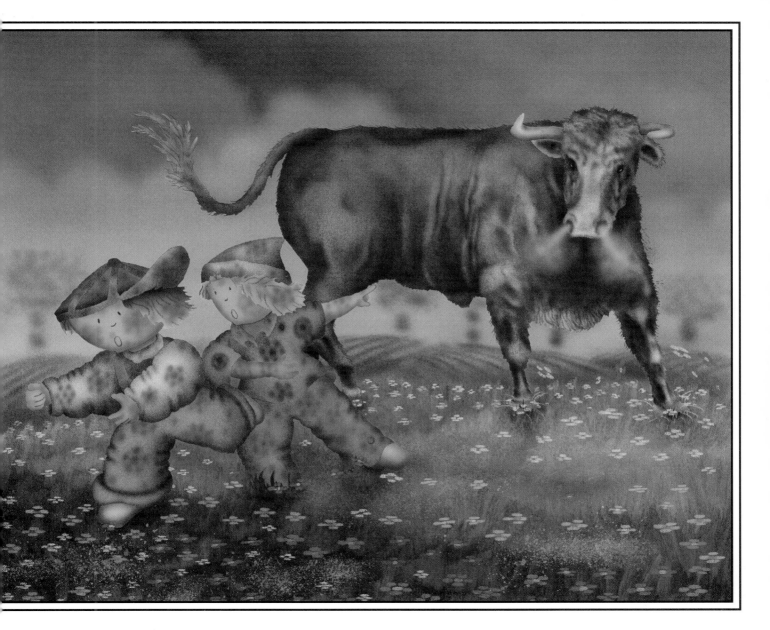

Marlene and I
sit on the mountain and rest.

I'm dreaming
while Marlene is thinking:
"Ooooh!" she says.
"I have a wonderful idea!"

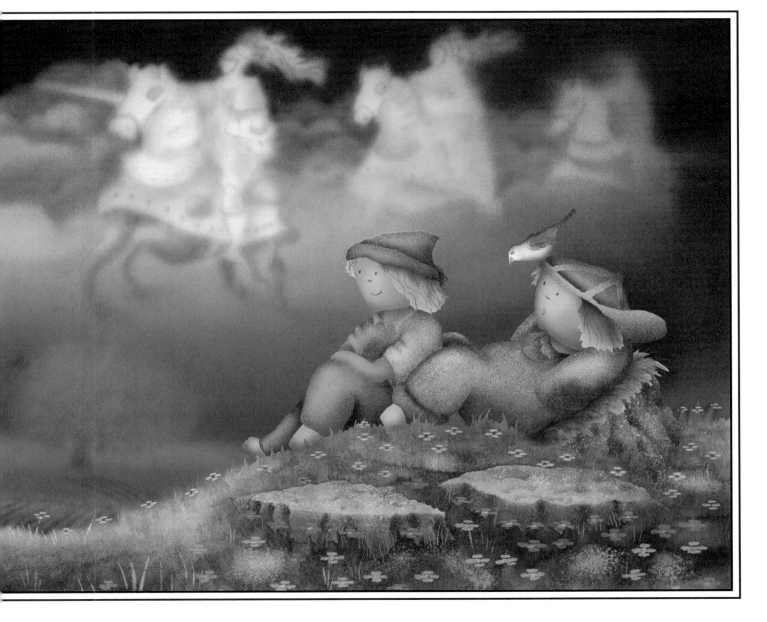

We call our friends!

They all come, disguised as ghosts,
as witches, as vampires
and all kinds of monsters.

YIPPEE! YIPPEE!
It's the best costume party ever!

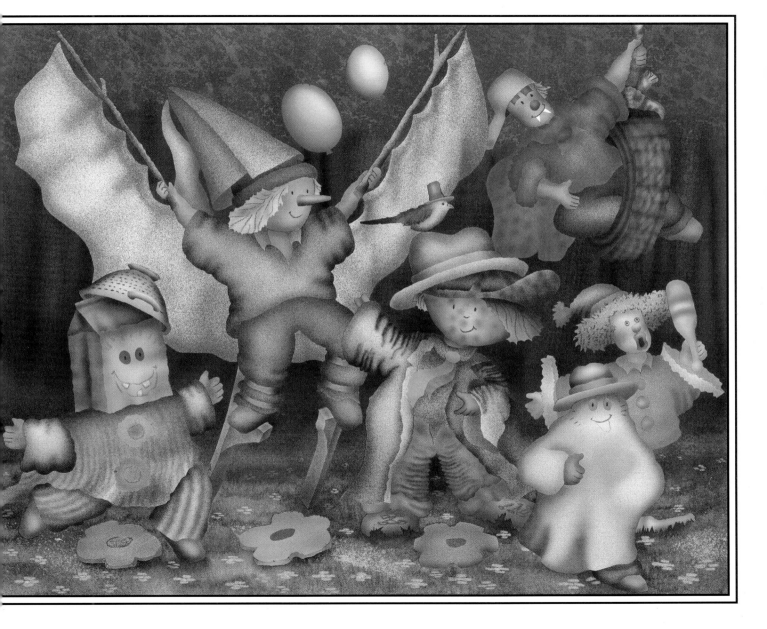

**To Charles,
the little "bike–rider"**

© **1999 Gilles Tibo**: text and illustrations

© **1999 Sheila Fischman**: English translation

Published in Canada by Tundra Books, *McClelland & Stewart Young Readers*,
481 University Avenue, Toronto, Ontario M5G 2E9

Published in the United States by Tundra Books of Northern New York,
P.O. Box 1030, Plattsburgh, New York 12901

Library of Congress Catalog Number: 98-75030

Canadian Cataloguing in Publication Data

Tibo, Gilles, 1951–
 [Simon et les déguisements. English]
 Simon's disguise

Translation of: Simon et les déguisements.
ISBN 0-88776-472-X

1. Fischman, Sheila. 11.Title. 111. Title: Simon et les déguisements. English.

PS8589.126S53813 1999 jC843'.54 C98-932432-X
PZ7.T5Si 1999

We acknowledge the support of the Canada Council for the Arts and the Ontario Arts Council for our publishing program.

We acknowledge the financial support of the Government of Canada through the Book Publishing Industry Development Program for our publishing activities.

Printed and bound in Canada

1 2 3 4 5 6 04 03 02 01 00 99